This journal belongs to:

How to Use This Journal

Doodling with Jim Henson Guided Art Journal offers an escape from the boring and mundane. Whether you choose to doodle or feel compelled to write, this journal is sure to spark your creativity. Follow the prompts on select pages to get your creative juices flowing, or write and doodle whatever moves you. Lose yourself in this lighthearted, whimsical world inspired by Jim Henson's original doodles, and let this journal and your imagination be your guide to creative fun.

This Scribble is the dreamer in you. He's ambitious and maybe a little idealistic at times, but he never lets obstacles keep him from achieving his lofty goals. What are your goals and dreams?

And then there are dreams—the sleep kind!

Doodle or write about what you remember from your dreams.

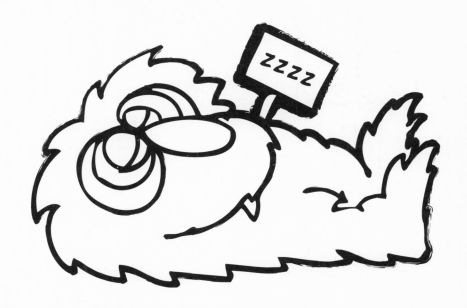

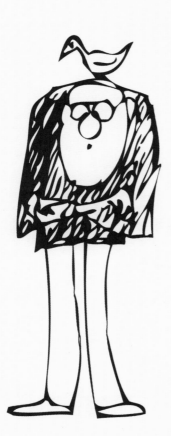

This Scribble is your inner glutton. This part of you is greedy, selfish, and won't take "no" for an answer! Think of a time when this not-so-pretty side of you surfaced. Doodle or write about it.

Doodle every single thing you can think of
that you really, really want. No limits or boundaries!

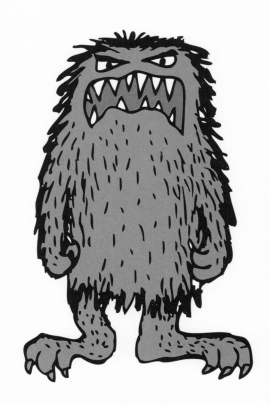

 This Scribble is your inner lump—the side of you that never wants to leave the couch and loves to nap all day. How do you like to spend your days being lazy?

What motivates you to get up off the couch?
Doodle or write about it below.

This Scribble is a wild child. This is the chaotic, jittery part of you that seems to have endless energy, like when you accidentally have too much caffeine or sugar. Aside from the typical energy boosters that you ingest, what activities or hobbies energize you?

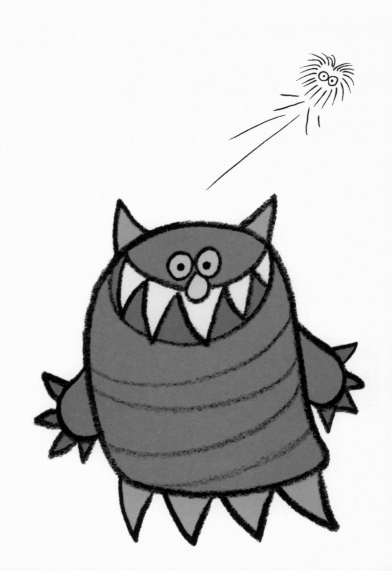

Doodle or list the things that make you go bonkers!

This Scribble is your inner goth—she lives in a world of darkness and pessimism, but really, she just wants to make the world a better place. Doodle or write about how you would change the world for the better.

What makes you feel depressed, sad, or down in the dumps?

This Scribble is the weirdo in you. He's the side of you that refuses to give in to the status quo, is quirky and misunderstood, and is probably even socially awkward at times. Doodle or write about the traits that make you unique.

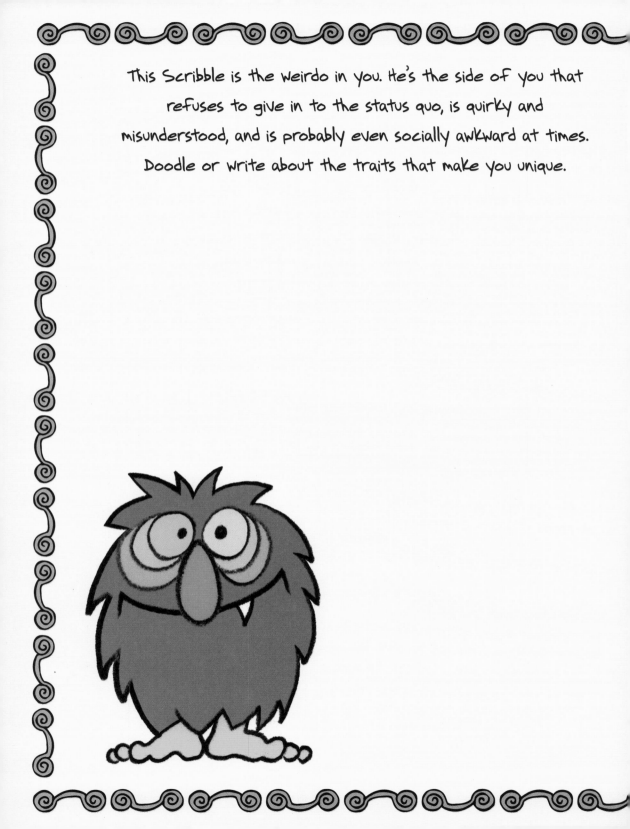

What are the weirdest or strangest experiences you've had?
Write about them!

This Scribble is your inner trickster—that rebellious, adventurous, sneaky, and occasionally reckless prankster who abides by his or her own rules. How often does this side of you come out? Write about it.

What's the most daring, adventurous, or rebellious thing you've done? Write about it, and then doodle the experience!

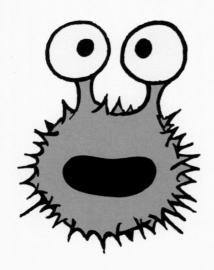

This Scribble is a blowhard. He is overly confident, loves the sound of his own voice, and is always trying to impress others. What are your most impressive accomplishments?

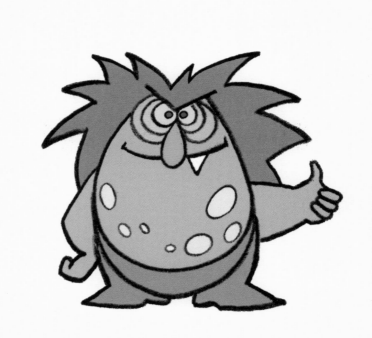

How often does your self-centered—even vain—side come out? Are there particular situations or people that bring out this side of you? Write about it below!

This Scribble is your inner softy. She's the sweet, cheesy, cuddly, kissy, hopeless romantic side of you that always sees the silver lining and lives in a perfect world. Write about or doodle the things you love most.

What makes you the most happy, content, optimistic, or hopeful?

This Scribble is totally awkward. This side of you is nervous, anxious, uncomfortable, and accident-prone. Write about what makes you anxious. How do you overcome these emotions?

What does your inner awkwardness look like? Doodle it!

This Scribble is your inner diva. She is confident, glamorous, and always wants to be the center of attention. Doodle yourself as rich and famous. What would your life look like?

Are there particular people or situations that bring out
your inner diva? Write about them below.

What does your dream house look like?

What do you like to do on rainy days?

What makes your skin crawl?

What makes you stand out in a crowd?

How are you feeling today?

What makes you smile?

Write about or doodle the things that scare you.

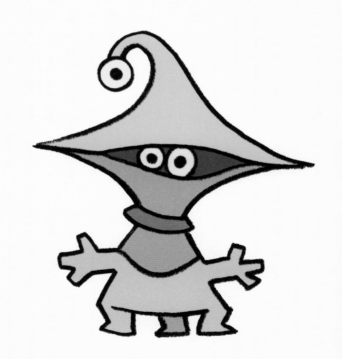

 Who is your secret (or not-so-secret) crush?

Doodle everything you love about nature.

What makes you feel like this?

What do you think these Scribbles are up to?

If you could be famous, who would you be,
what would you do, and why?

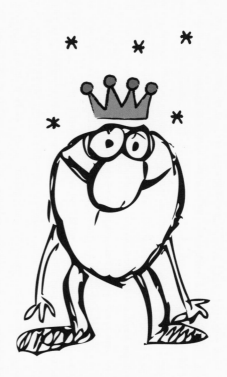

What kind of person are you?

Clean and tidy? Messy and disorganized? Casual and carefree?

If you could snap your fingers and have whatever you most desire, what would it be?

What makes you shuffle and jive?

If you could fly anywhere,
where would you go?

What do you find important enough
in life to chase after?

Everyone needs someone to lean on.

Doodle or write about the qualities that make a good friend.

When you are feeling hopeless, how do you
pick yourself up again?

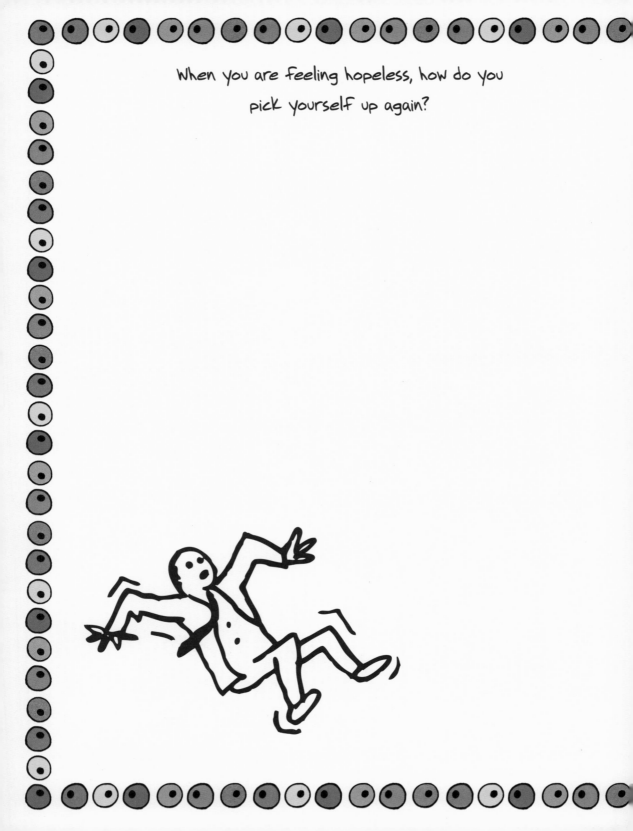

Friends and family add so much richness to your life.
What do you like most about the people around you?

Jim Henson
THE JIM HENSON COMPANY

Select prompts by Janessa Osle.

Walter Foster

www.walterfoster.com
3 Wrigley, Suite A
Irvine, CA 92618

Printed in China.
1 3 5 7 9 10 8 6 4 2